BLACK VELVET

The Art We Love to Hate

JENNIFER HEATH

POMEGRANATE ARTBOOKS San Francisco

For Clara Redmond, Diane Rothenberg,
Alberto Torres and Jack Collom

Published by
Pomegranate Artbooks
Box 6099
Rohnert Park, California 94927

Special thanks to the Puffin Foundation,
the Colorado Dance Festival, the Boulder Arts
Commission, Isabella Armijo-Beeson,
Elizabeth Bell, Sarah Bell, Tree Bernstein,
Howard Bittman, Thomas Burke,
Christopher Collom, Richard Colvin, Linda Ellis,
Guillermo Gómez-Peña, Matthew Heath,
Tim Lange, Lucy R. Lippard, Mary Jane Makepeace,
Marilynne Mason, Mike O'Keeffe, Elvis Presley,
Nancy Robertson, Mabeth Sanderson,
Nicole Seeds, Diana Somerville,
Ivan Suvanjieff, the terrific editors and
designers at Pomegranate and, especially,
all the extraordinary artists who contributed
to "The Art We Love to Hate: Black Velvet"
for making this project possible.

Photographs of Benito Huerta's *Blue (Rumblings)*
and *The Hive* courtesy Hickey-Robertson;
all other photographs courtesy Ken Abbott.

ISBN 1-56640-971-3

Library of Congress Catalog Card Number 93-87361

Designed by Bonnie Smetts Design

Printed in Korea

Krissy

CONTENTS

Introduction

Velvet painting is the most despised art form in the world—and perhaps the most popular. Although antique velvet paintings are treasured and carefully catalogued by collectors of fine art, contemporary velvet painting is generally scorned by critics as the ultimate in tastelessness. Today's velvet painting has been virtually ignored by folklorists and historians. Yet it is a time-honored medium, beloved and collected by people who have little acquaintance with or access to the established art world. It has spread around the globe, from London to Beijing, and is, in fact, only a latecomer to Mexico, where it developed its reputation as the art we love to hate.

Velvet art has a long, illustrious history. It apparently originated in Persia, where the fabric was first produced using silk imported from China. Floral and nonfigurative patterns in the Islamic tradition, and decorative gold and silver threads, were woven directly into the warp. During the Crusades the cloth was brought to Europe, where splendid, laboriously produced ornamental velvets, ranging from royal garments to upholstery and horse trappings, reached their peak in fifteenth-century Italy.

In the eighteenth century French weaver Gaspard Grégoire painted on threads before they were woven into the velvet, which allowed him to create more intricate designs. The Los Angeles County Museum collection includes examples of Grégoire's work—inimitable because he never revealed his technique.

The Portuguese are thought to have introduced velvet in China in the sixteenth century: its first known mention there is in a Portuguese trader's log dated 1551. From China, velvet art made its way to Japan. A fascinating example of a Japanese velvet painting, circa 1880, is now housed in London's Victoria and Albert Museum. Depicting a lion, it foreshadows a recurring theme in Mexican velvet paintings of crouching jaguars and stalking tigers.

In the mid-nineteenth century the monied classes in England and New England took up "theorem painting," which, when done on velvet, was termed "Oriental painting." In the pre-Victorian era painting on velvet was considered "the flower of all things desirable in the education of young ladyhood." Oil and watercolor, black and white velvet, and stencils were mail-ordered; popular motifs included still lifes—fruit arrangements were especially fashionable—as well as landscapes and idealized,

5

imagined architecture in the Greek classical mode. The theorem fad ended in the 1850s, but by then velvet painting had gained momentum. Theorem and antique velvet paintings in the National Gallery of Art in Washington, D.C., the Antiquarian Society of Concord, Massachusetts, and other folk art museums and private collections are highly prized.

Today there are more or less identifiable regional velvet painting styles among European-American communities. In Montana and Idaho orange and green velvet are preferred for idyllic western landscapes. Along the Virginia coast a "Turner" approach is used in depicting ships at sea in foggy light. In Appalachia a "school" of velvet art reputedly features a skeleton carrying pistols, Confederate flags, bandoliers and banners emblazoned with the slogan "The South Will Rise Again!" There is a dwindling but continuing tradition of making "mourning" paintings on black velvet to memorialize the dead, and echoes of the theorem fad now appear in toy store chains, where black velvet paint-by-number sets offer such subjects as clowns, horses and wide-eyed children.

Contemporary amateur Euro-velvets have a distinctly different flavor from their Latino counterparts. They reach harder toward a semblance of fine art—and frequently fail, for unlike the Mexican pictures, they usually lack a sense of irony and humor. Often painted on primary-colored polyester rather than the black velveteen, plush rayon velvet or, very occasionally, flocked paper used by Mexican artists, they seem to have a clumsier texture, and they portray nostalgic, generalized ideals: kittens, unicorns and Huck Finns heading for the fishin' hole.

Frontera velvet artists have happily exploited this *norteño* taste for trite images. Yet right along with the tacky and trivial, original and delightfully idiosyncratic velvets are painted north and south. Even in the shameless kitsch—Smurfs and Snoopys—the light is immense, a brilliant luster intrinsic to the medium. Landscapes are illuminated from left and right in red and blue, like blaring movie lighting. Few subtleties are possible: whatever the subject, its emotional and theatrical levels are intensified with tortured radiance. But playfulness inevitably shines through even in the most solemn pictures.

In U.S.-Mexico *frontera* velvet factories the work is collaborative. One artist paints the leaves of a tree, the Virgin's cape or the Pink Panther's grin.

Women paint the flowers. Some team paintings are completed in thirty minutes. When the work is finished, the factory *patrón* signs it. Independent artists also churn out dozens of multiples. Signatures dignify the work and define it as art and personal expression. But these scrawled names seem anonymous and generic from the Euro-American point of view, which glorifies individuality and artistic recognition.

Mexican export companies move thousands of paintings to U.S. wholesalers. Itinerant salesmen travel from town to town peddling the paintings, whose low prices do not always include a "genuine Spanish colonial-style" scored-wood frame. Often exhibited leaning against vans in deserted gas stations, the paintings also can be found in souvenir warehouses, piled atop one another like so many TV dinners, and at starving-artist sales, thrift stores and garage sales. It is not easy, however, to find the Virgin of Guadalupe or the figure of Christ on velvet for sale in a *segundo*. People don't relinquish these paintings. They become integral elements in household shrines on both sides of the border.

The precise origins of velvet painting in Mexico are not clear. Although some Tijuana artists believe it came from the

Philippines in the 1930s, there has long been a custom in Jalisco and other areas of painting on velvet fiesta clothing—circular dancing skirts and mariachi costumes.

Spanish influence dominated early Mexican velvet art, which portrayed conquistadors and Columbus's *Niña, Pinta* and *Santa María,* but indigenous and popular themes soon surfaced. One perennial favorite native motif is that of the Aztec warrior and maiden Ixtaccíhuatl and Popocatépetl, for whom Mexico's two famous volcanoes are named. Velvet artists stencil the couple in many swooning poses, but Tijuana painter Tawa follows this beautiful, ancient legend of love lost and transformed into nature, scene by scene, meticulously by hand, and his magnificent work commands great respect.

In the 1950s, when Elvis was king, American tourists shopping for cheap goods across the border bought his black velvet portrait by the thousands. Today Bruce Springsteen, Jimi Hendrix and other rock 'n' roll stars—the folk heroes of our age—also rule the velvet roost. John Wayne marches on as upholder of machismo, with Clint Eastwood not far behind. The Virgin of Guadalupe continues as always, unmoved by trends in pop culture. As pride

in *la raza* increased, revolutionaries replaced invaders: Hernán Cortés finally disappeared and the faces of César Chávez, Martin Luther King, Jr., Emiliano Zapata, Jesse Jackson and Nelson Mandela appear proudly alongside masked Mexican wrestling superstars—guardians of justice one and all. These healer-heroes are affirmations that a force exists to protect and uplift the downtrodden.

The familiar theme of dogs playing pool or poker may have its roots in the early-twentieth-century paintings of humanized canines by American Cassius Marcellus Coolidge, and the *Playboy* pinups of Alberto Vargas are revived in buxom blonde velvet truck-stop nudes. Many paintings, like *The Last Supper,* appropriated from da Vinci, are reproductions of classic European and American art: Frederick Remington's *End of the Trail* is a ubiquitous item at rest area boutiques; Mona Lisa reappears, her complexion, like the Virgin of Guadalupe's, reflecting indigenous tones. Are these reconstructions merely salable tourist items, or are they also culturally adapted tributes?

Contemporary velvet painting is considered so crude, vulgar and commercial that even independently created works—painted for the sheer joy of art making—do not rate the dubi-

ous distinction of "folk art," a convenient label frequently applied to art that has no academic place, art that is considered "ethnic," "low" or "primitive." The now-treasured theorem paintings were as mass-produced as any factory velvets, but they have achieved the patina of respectability that comes with age. As a true art of the people, today's velvet painting needs no scholarly stamp of approval.

Rasquachismo describes Chicano aesthetics, "the attitude, tastes or life-style of the underdog," as historian Tomás Ybarra-Frausto writes, "where status is elevated with garish decoration." Velvet painting is a vital trademark of *rasquache,* a term used today among Chicanos "to articulate a stance that repudiates the Anglo experience." (Its meaning is roughly equivalent to "white trash.") The velvet paintings of Carlos Fresquez, Anthony Ortega, Francisco Zamora and Carlos Santistevan testify to the continuing references by Chicano artists to their roots. Performance artist and writer Guillermo Gómez-Peña used velvet painting aesthetically and politically in his 1988 installation, "Velvet Painting Hall of Fame," which features Tijuana artist Beto Ruiz's critically acclaimed *Border Brujo* and *Yuppie Bullfighter.*

Houston artist Jorge T.'s "cartoonlike" velvet paintings are, as critic Lucy R. Lippard writes in her book *Mixed Blessings,* "a deliberate challenge to mainstream taste," a "quest for a style that would reconcile the humor and political perversity of *rasquachismo* with the formalist framework of Jasper Johns or Al Held."

Other contemporary American artists employ the medium seriously or as a novelty. Paul Mavrides, Eleanor Dickinson, Peter Alexander and Julian Schnabel have explored the visceral, pungent and luscious potential of velvet. More than thirty artists of varying ethnicity—Ivan Suvanjieff, Jill Hadley Hooper, Clark Richert, Dale Chisman, Nancy Robertson and Linda Ellis,

among others—experimented with the medium for a traveling exhibition: "The Art We Love to Hate: Black Velvet." The results were diverse, inspiring and challenging to artists and viewers alike. Their work extended the content and meaning of the genre through expressionism, realism, sculpture, sociopolitics, religious symbolism and satire.

Velvet painting has become the blue-light special of art forms, satisfying a yearning for memory and beauty in people worldwide for whom "high" Euro-art is beyond reach or interest. Popular Philippine velvets honor shadowy *lolos* and *lolas*—grandfathers leaning on their walking sticks and grandmothers threading needles— while in Hong Kong, Tahiti and

Hawaii skillfully rendered imitations of Gauguin are everywhere, paired with passionate tropical landscapes of the kind sold by the hundreds during the 1950s by painter Edgar Leetag, immortalized in James Michener's *Rascals in Paradise.*

Black velvet art is nothing if not breathtaking—even overwhelming. It may be considered laughable camp in some circles, by its very nature simultaneously defining and undermining stereotype. But the uncrowned queen of kitsch is truly crosscultural, transcending place and social identity. Velvet painting has unique historical and contemporary significance and deep cultural roots. At its best, it is a heroic, epic art form that expresses sociomythic concerns and cultural pride.

BLACK VELVET

BORDER BRUJO

Jorge T. (Tijuana)

Conceived by
Guillermo Gómez-Peña

Painting on black velvet

24 x 36½ in.

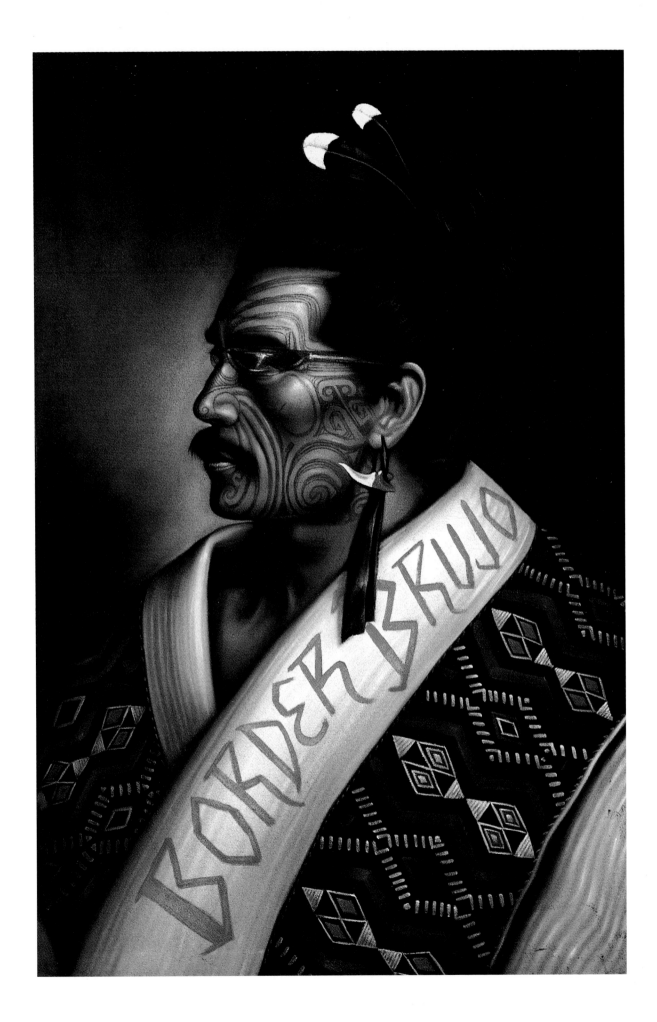

ELVIS

Mass-produced, Juárez;
artist unknown

Painting on black velvet

28 x 39 in.

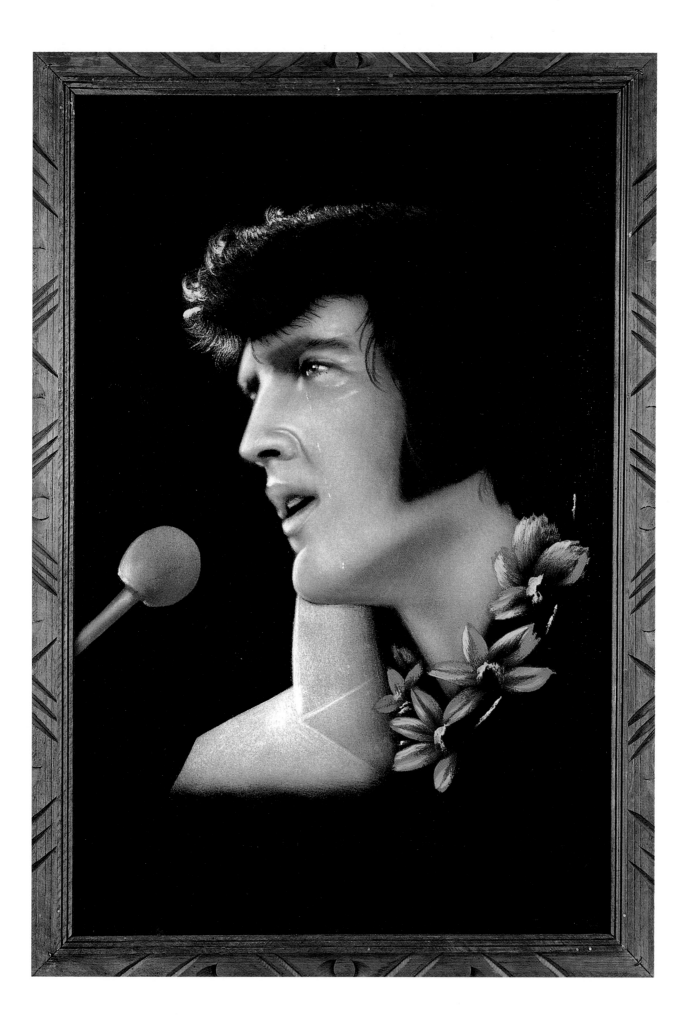

JOHN LENNON

John Patrick Kelly
(Denver, Colorado)

Mixed media on green velvet

12 x 23¾ in.

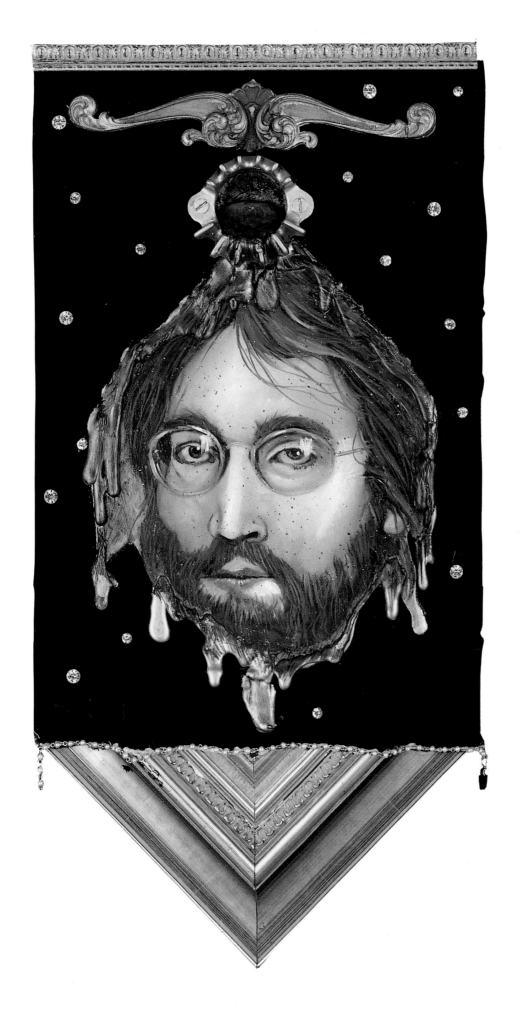

TIGER

Artist unknown;
purchased from San Francisco
Mission District thrift shop

Painting on black velvet

39 x 27 in.

Courtesy Elizabeth Bell

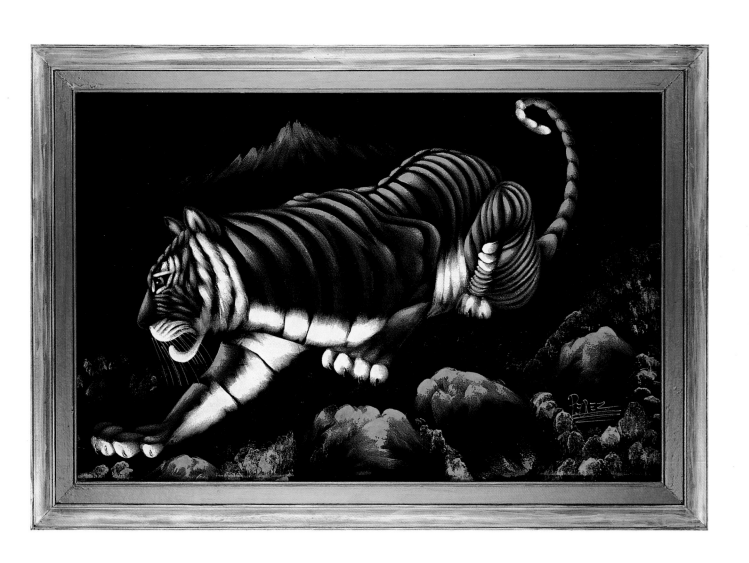

DOGS PLAYING
POOL

Mass-produced, Juárez;
artist unknown

Painting on black velvet

39½ x 27½ in.

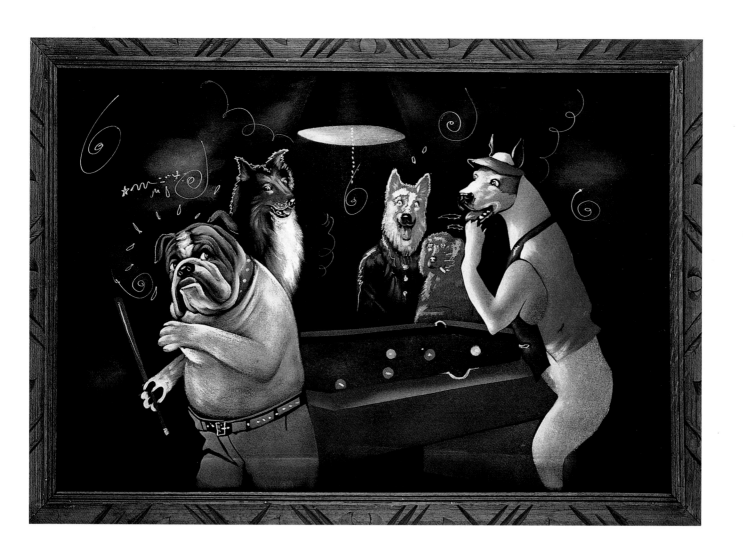

LA VIRGEN DE GUADALUPE

Mass-produced, Juárez;
artist unknown

Painting on black velvet

19½ x 23½ in.

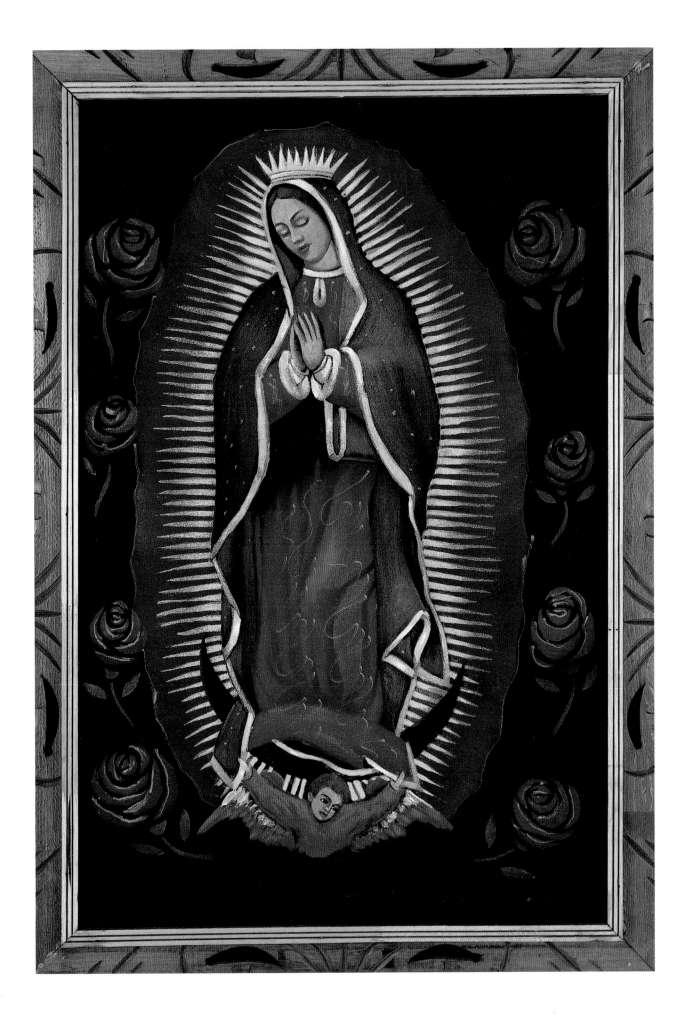

QUEEN KING LORD FOOL

Peter Cole
(San Francisco, California)

Mixed-media assemblage
on mass-produced
black velvet painting

13¼ x 23½ in.

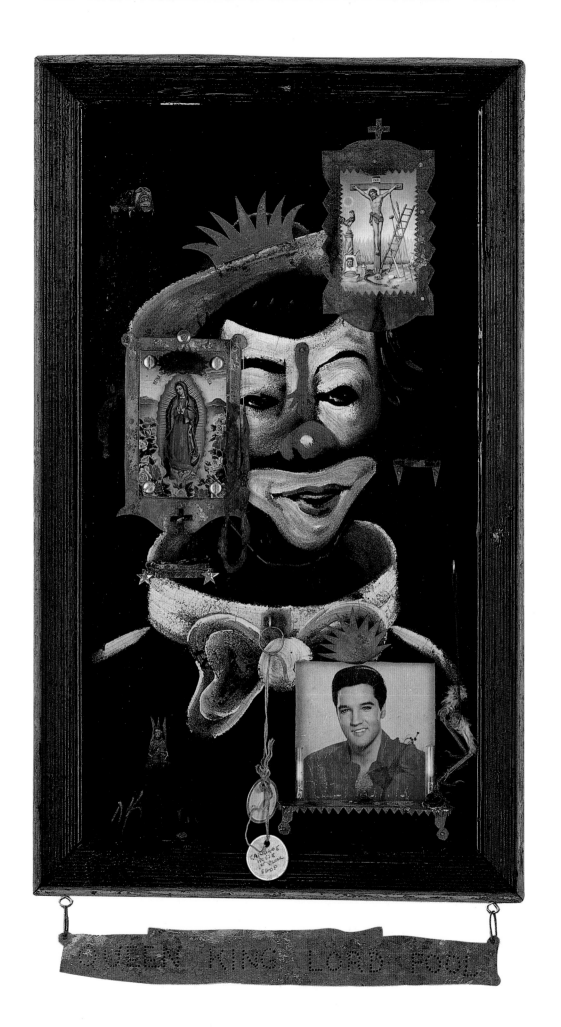

BLUE BULL

Artist unknown;
purchased from souvenir shop

Painting on black velvet

$37\tfrac{1}{4}$ x $27\tfrac{3}{4}$ in.

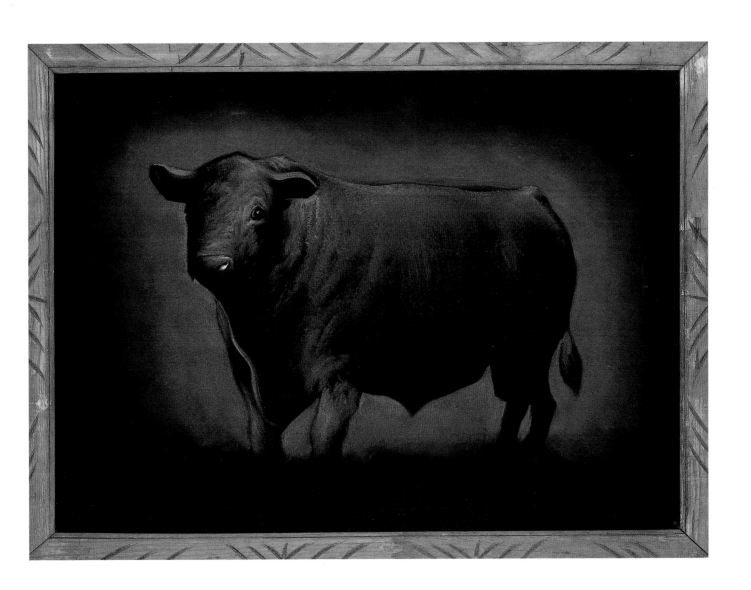

TIJUANA NUDE

Beto Ruiz (Tijuana)

Painting on black velvet

18 x 24 in.

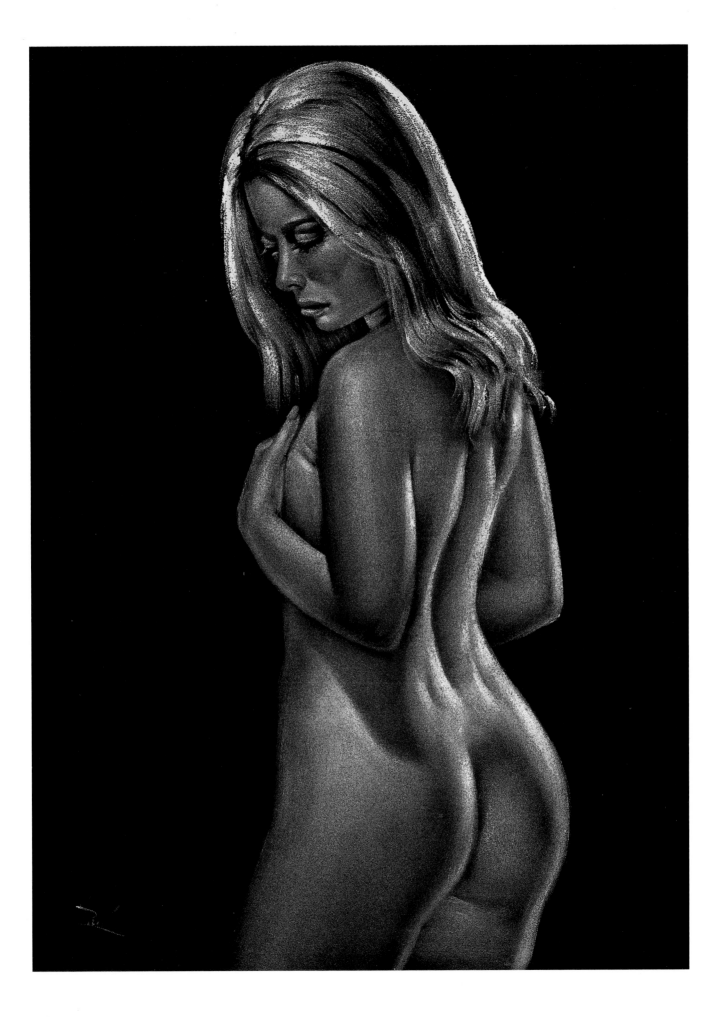

EL REY, EL VEZ

Anthony Ortega
(Denver, Colorado)

Acrylic on black velvet

28 x 31½ in.

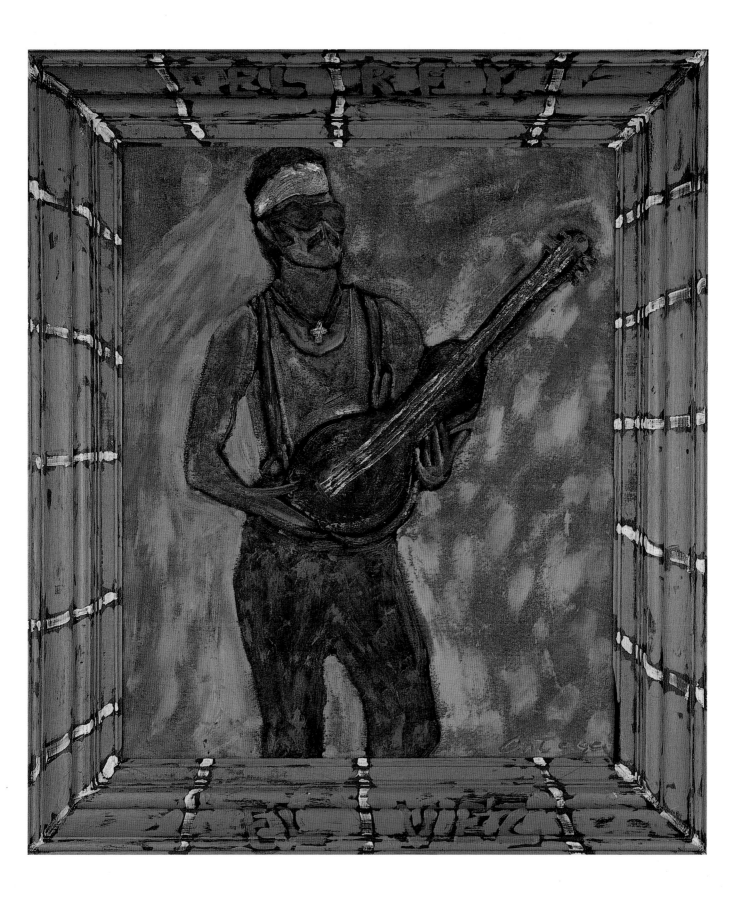

PAINTING FOR ANITA

Kristine Smock
(Boulder, Colorado)

Acrylic on black velvet

19½ x 23½ in.

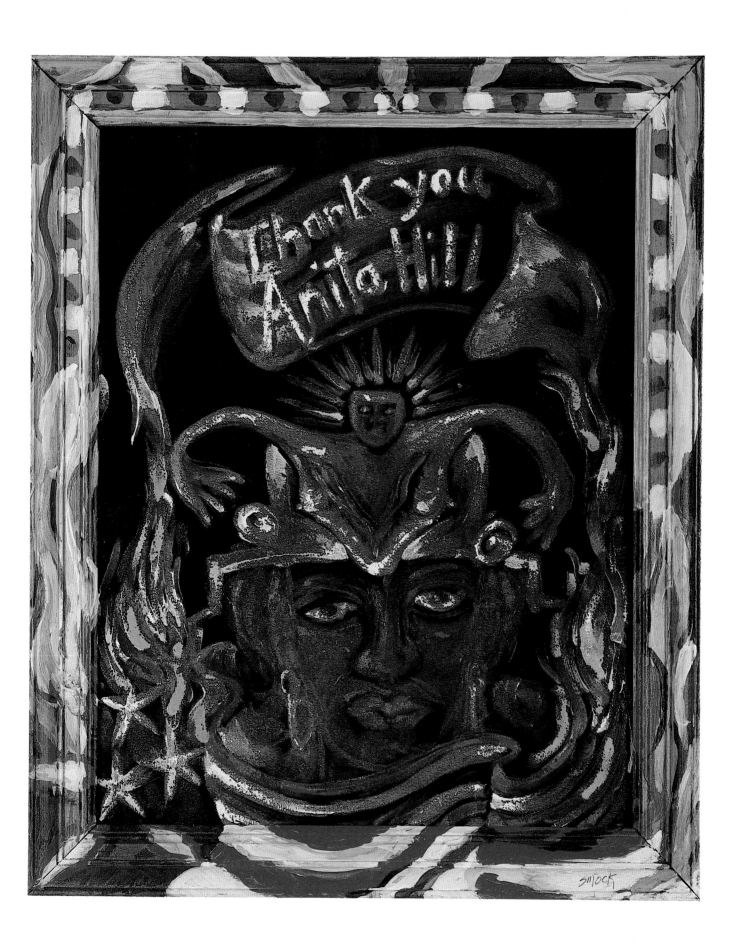

LION

Japanese velvet painting,
c. 1880; artist unknown

Courtesy
Victoria & Albert Museum,
Victoria & Albert
Picture Library

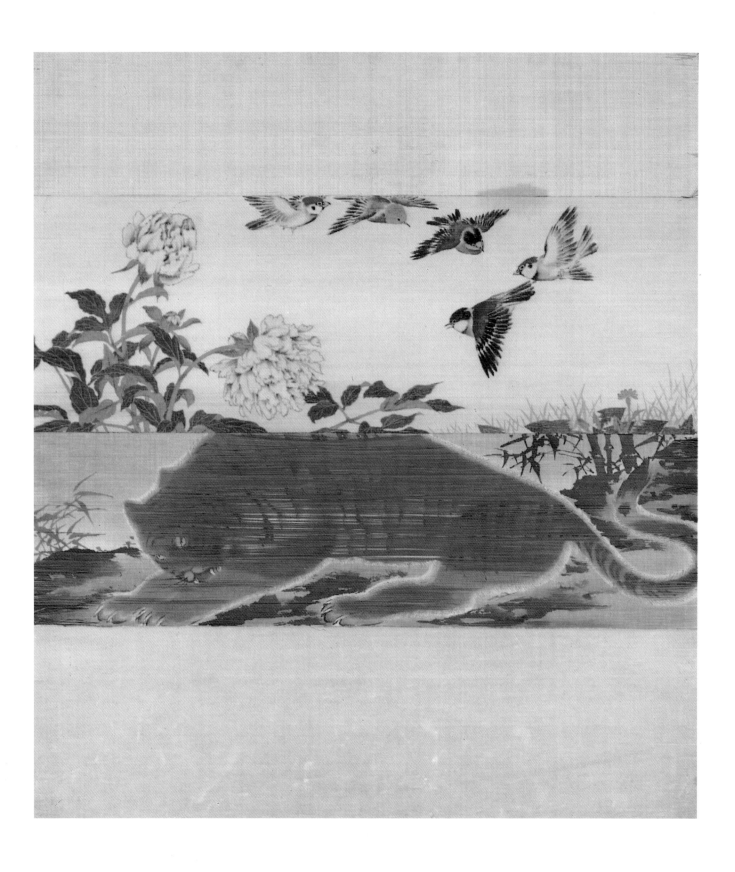

BOY WITH BURRO

(right and left panels)

Mass-produced black velvet
paintings, artist unknown;
purchased at flea market

Each panel 13½ x 22½ in.

Courtesy
Jean-Edith Weiffenbach

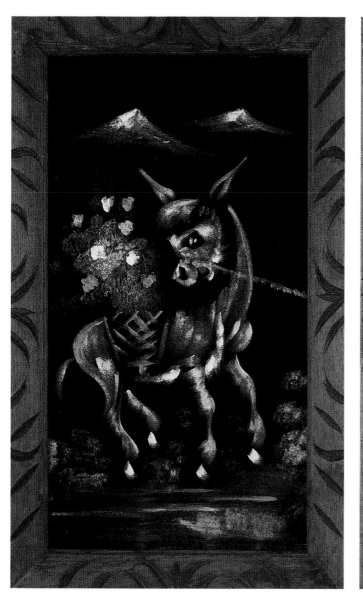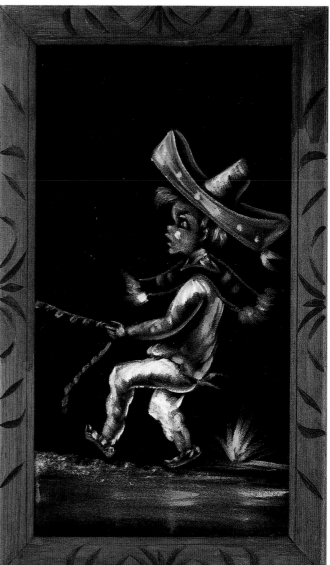

NIGHT LIGHT

Carlos Fresquez
(Denver, Colorado)

Acrylic on black velvet

53½ x 37½ in.

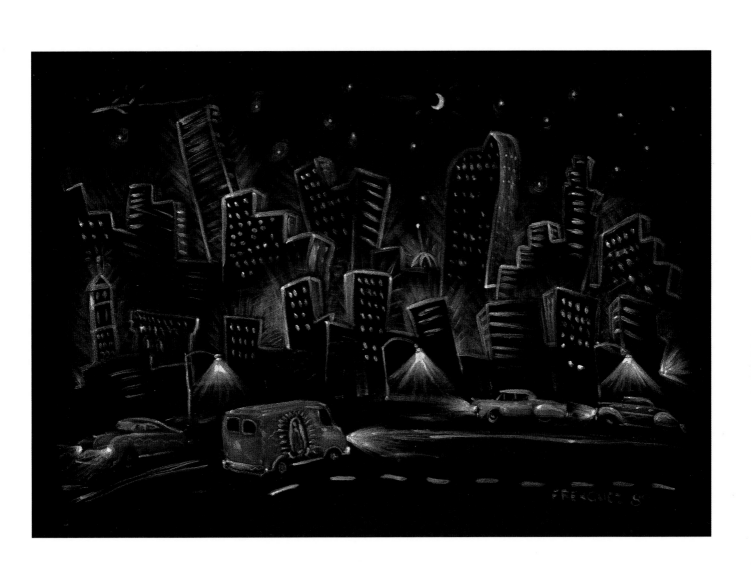

POLYNESIAN MAIDEN

Col. J. Craig Hille III

Oil on black velvet

34 x 44 in.

Courtesy John Patrick Kelly

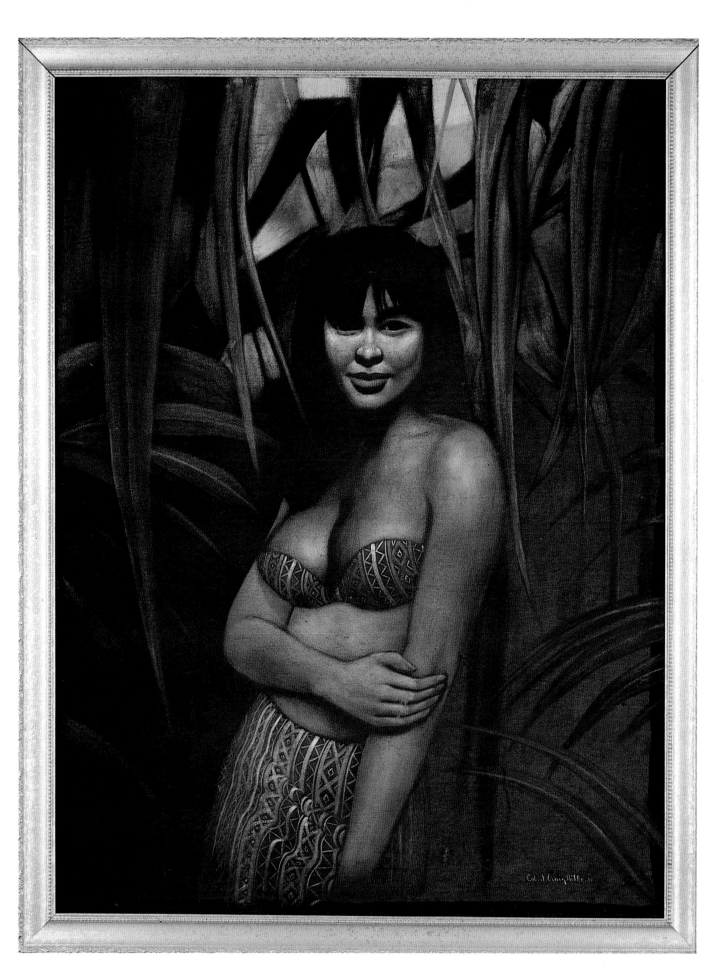

VINCENT'S VAN GOES WEST

Sandra Kaplan
(Denver, Colorado)

Mass-produced black velvet
painting enhanced
with fabric glitter

22½ x 14 in.

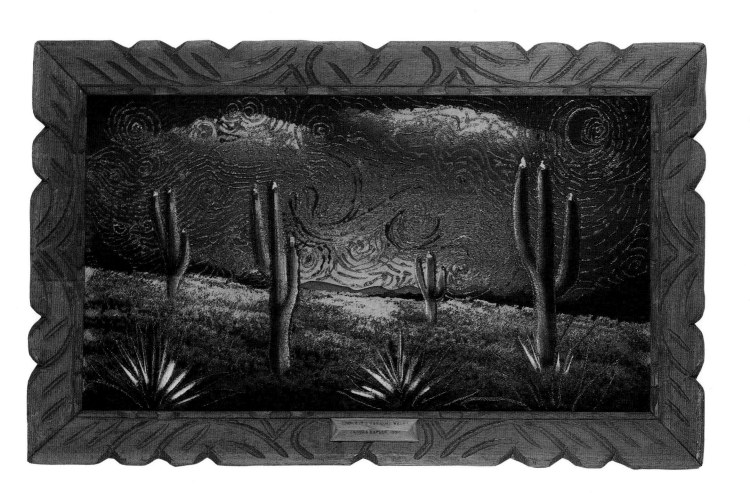

AFRICAN MASK
WITH FEATHER

Kay Miller
(Boulder, Colorado)

Acrylic on black velvet
with beads

26 x 35 in.

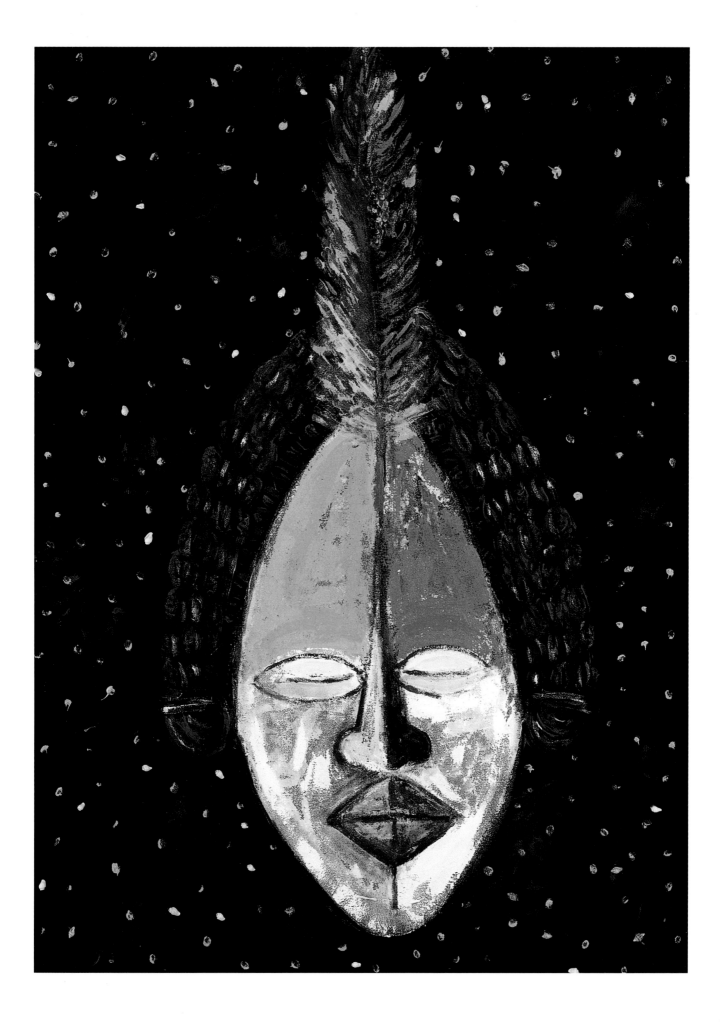

SOFA-LENGTH MATADOR

Artist unknown;
purchased from thrift shop

Painting on black velvet

50 x 27 in.

Courtesy Joseph Richey
and Anne Becher

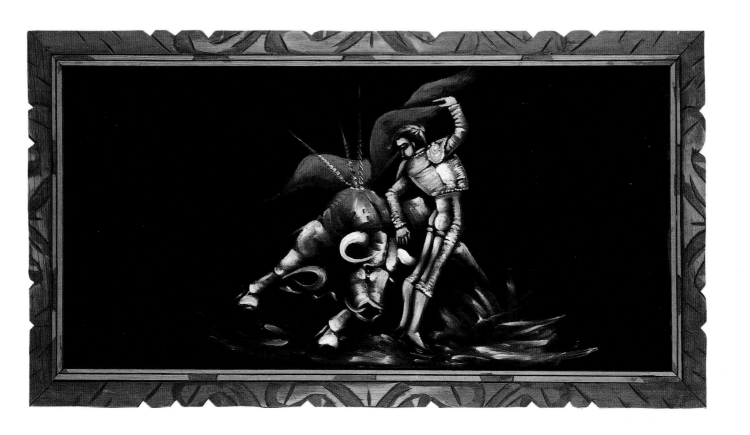

QUE CHEVRE
LA MATADORA

Carlos Santistevan
(Denver, Colorado)

Acrylic on black velvet

14 x 17¼ in.

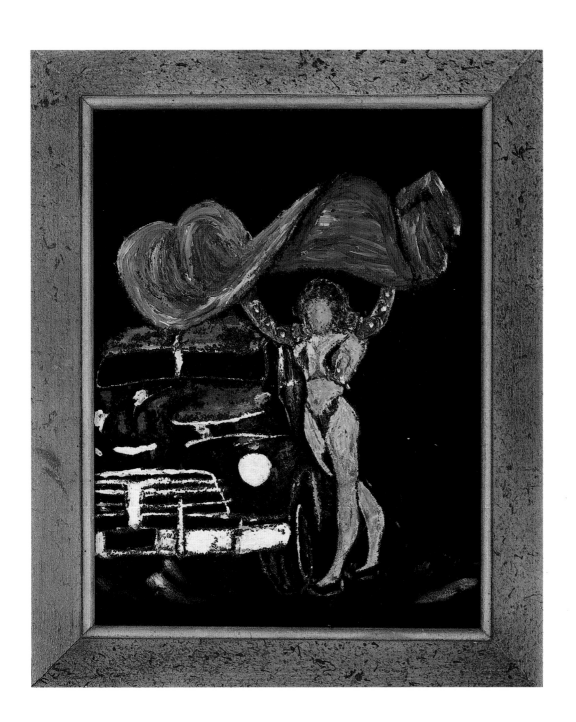

SMURF

Artist unknown;
purchased from
Denver flea market

Painting on black velvet

10 x 14 in.

Courtesy Michael O'Keeffe

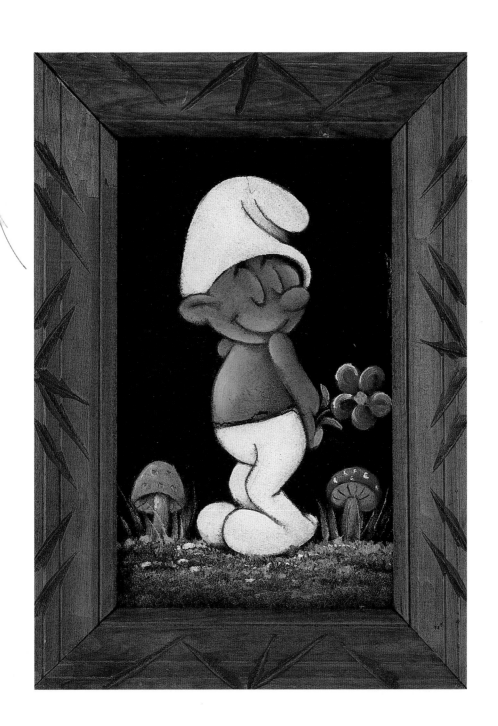

LANDSCAPE

Artist unknown;
purchased from Idaho
thrift shop

Painting on red velvet

35½ x 29½ in.

Courtesy Kristine Smock

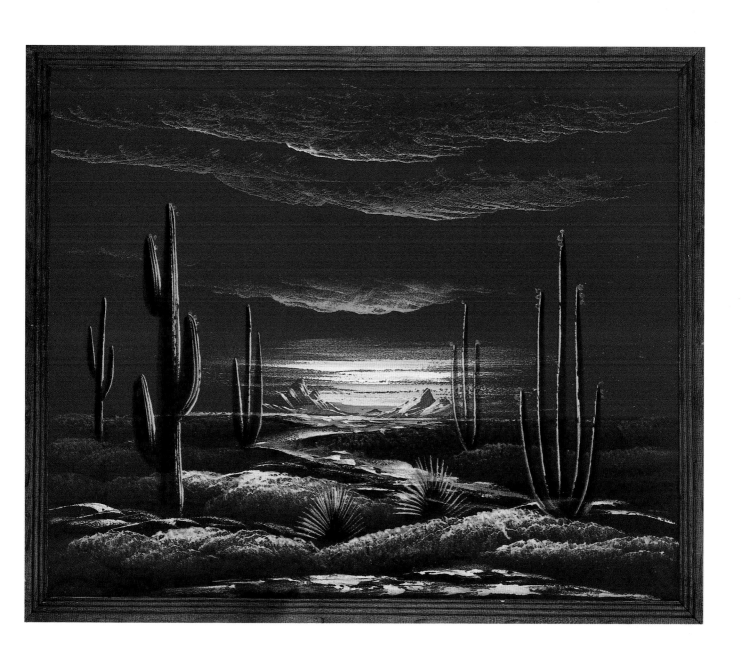

SKULL SHIRT

Carla Madison
(Denver, Colorado)

Mass-produced black velvet
painting from Nogales,
enhanced with rhinestones
and made into a garment

23½ x 29 in.

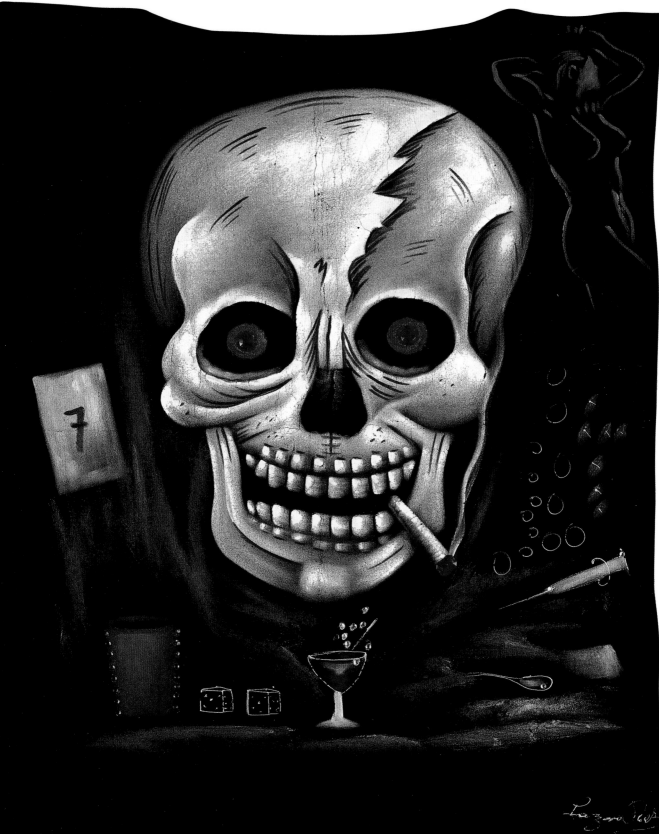

END OF THE TRAIL

Artist unknown;
purchased from Arizona
roadside stand

Painting on purple velvet

24 x 20 in.

Courtesy Tree Bernstein

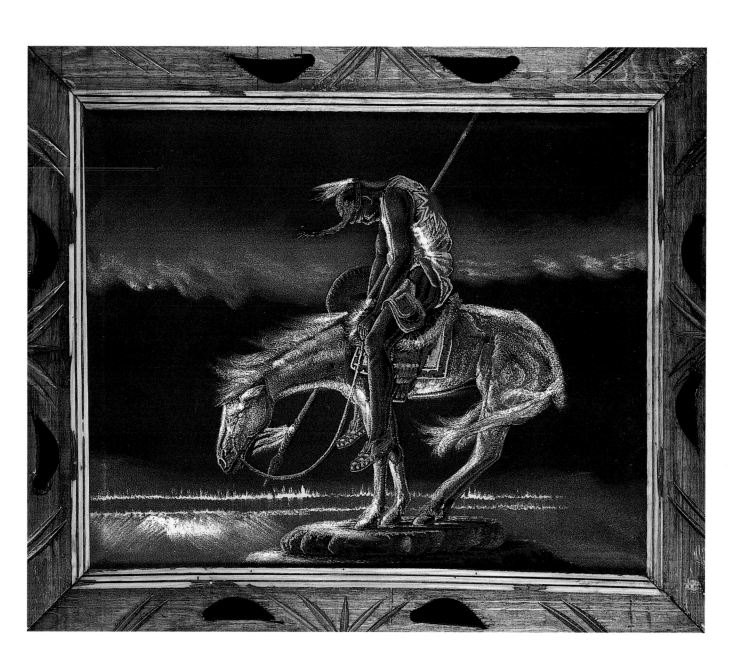

YUPPIE BULLFIGHTER

Jorge T. (Tijuana)

Conceived by
Guillermo Gómez-Peña

Painting on black velvet

24 x 36½ in.

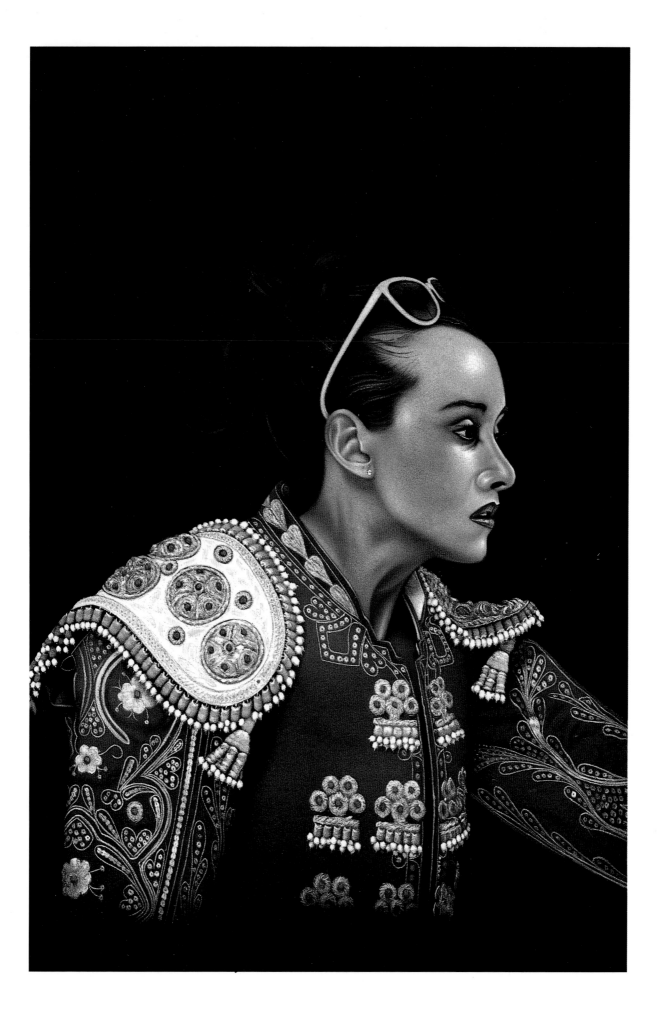

JOHN WAYNE

Mass-produced, Juárez;
artist unknown

Painting on black velvet

39 x 27¼ in.

Courtesy Kent and
Norene Berry

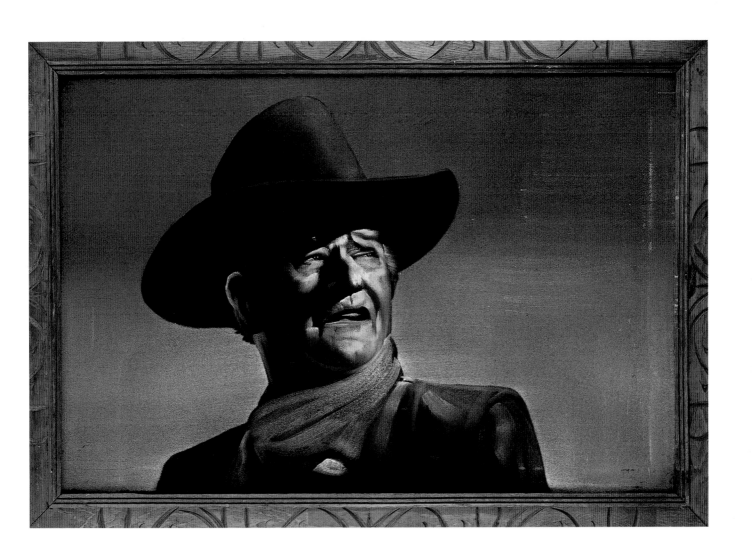

TIJUANA BABY BOY

Mass-produced, Tijuana;
artist unknown

Painting on black velvet

14 x 20 in.

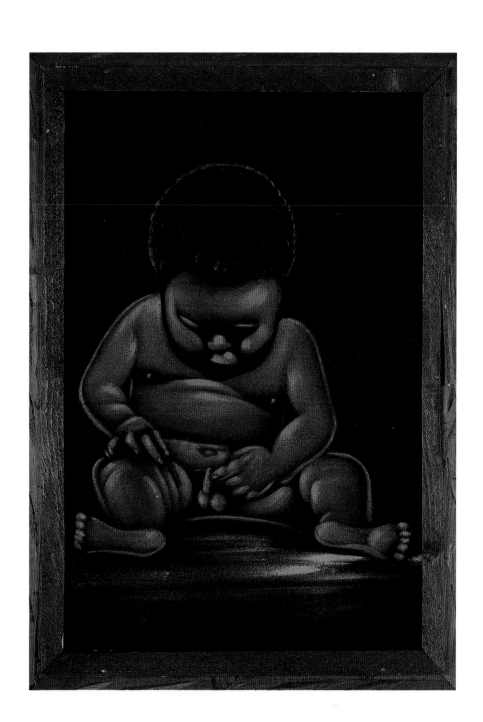

JESUS ON THE MOUNT OF OLIVES

Mass-produced, Juárez;
artist unknown

Painting on black velvet

38 x 26½ in.

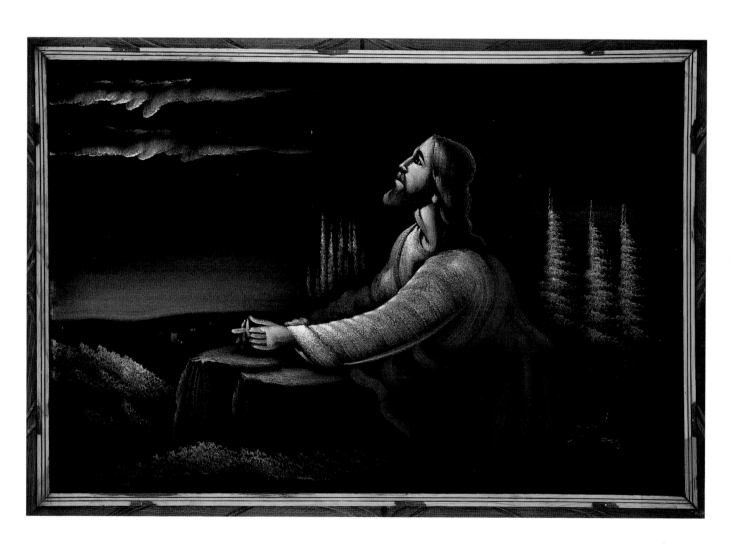

LA FUERZA

Francisco Zamora
(Denver, Colorado)

Ceramic and oil assemblage
on black velvet painting

11 x 23½ in.

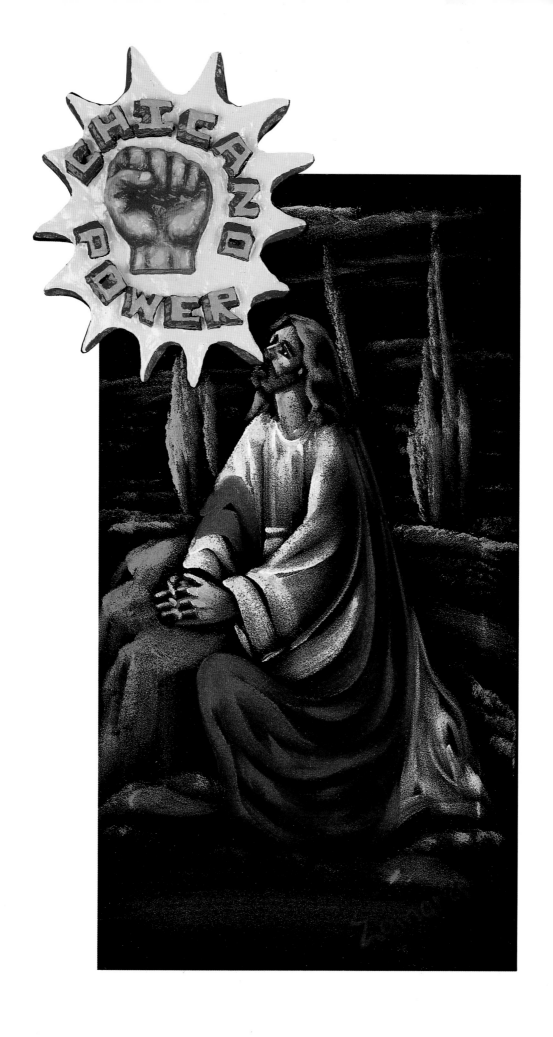

MONA LISA

Artist unknown;
purchased from thrift shop

Painting on black velvet

20 x 24 in.

Courtesy Richard Colvin

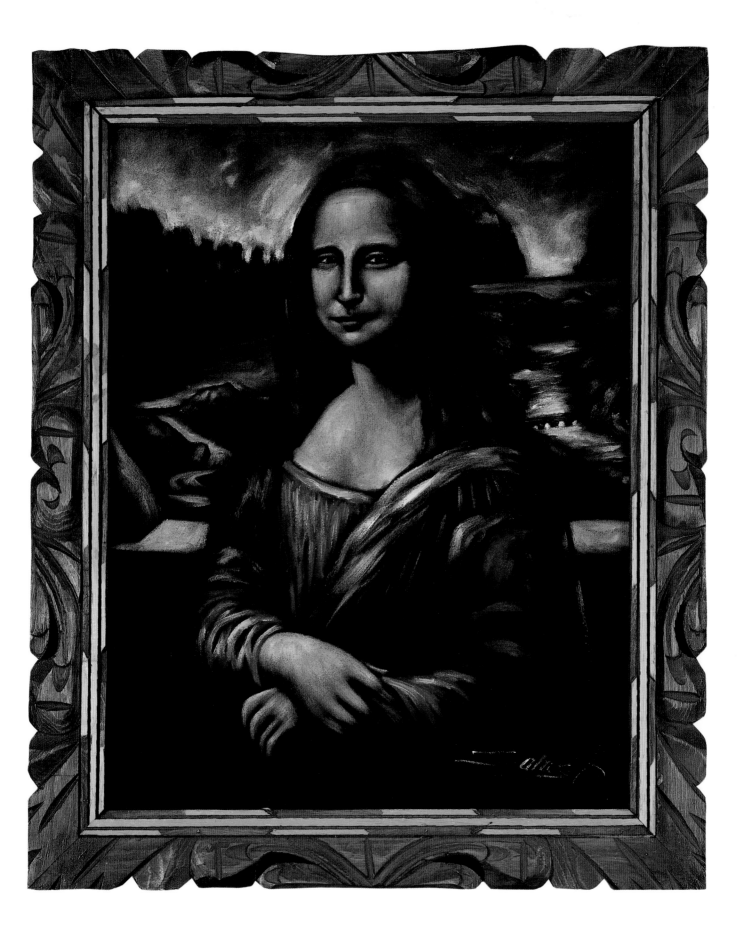

GOD BLESS
OUR HOME

Artist unknown

New England folk painting
on black velvet

32 x 17½ in.

Courtesy Lucy R. Lippard

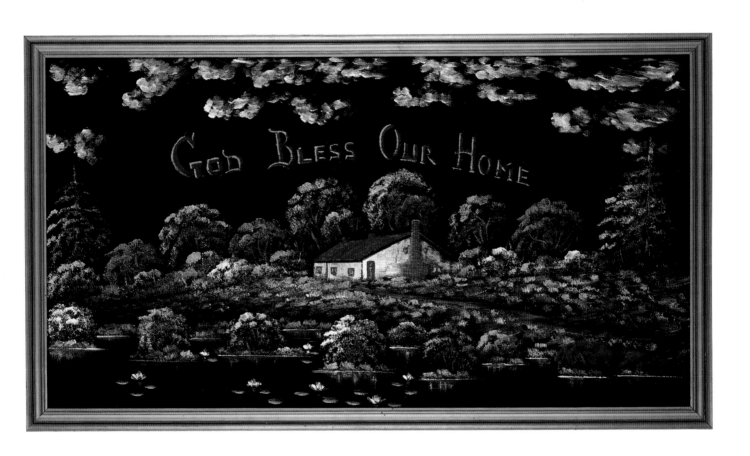

MY HEART BELONGS TO CUBA

Betty Kano (Berkeley, California)

Mixed-media double-scroll
assemblage with eucalyptus leaves

21 x 44 in.

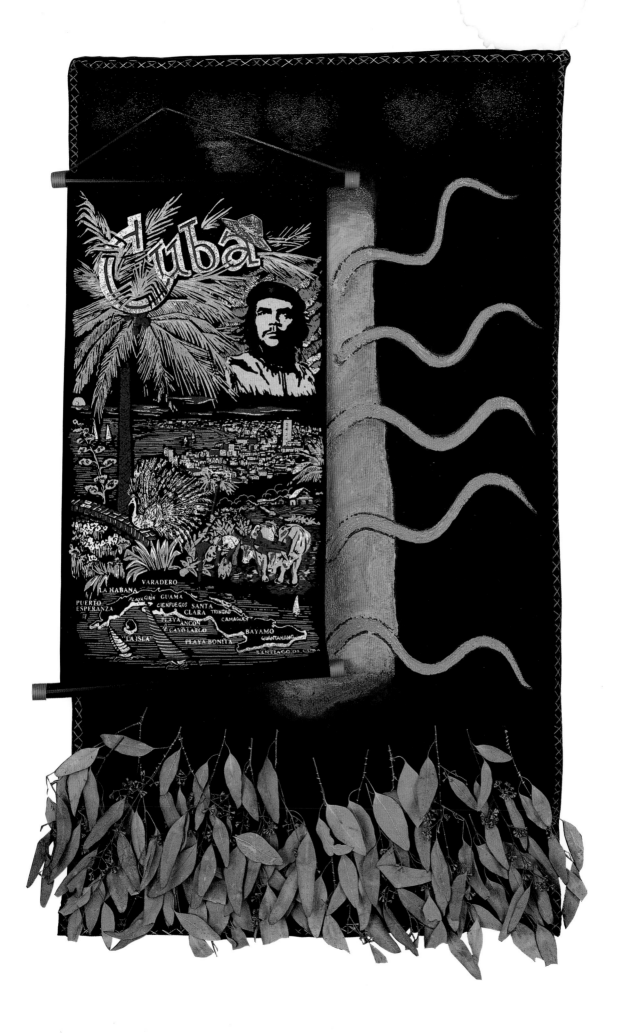

BLACK PANTHER

Mass-produced, Tijuana;
artist unknown

Painting on black velvet

24 x 18 in.

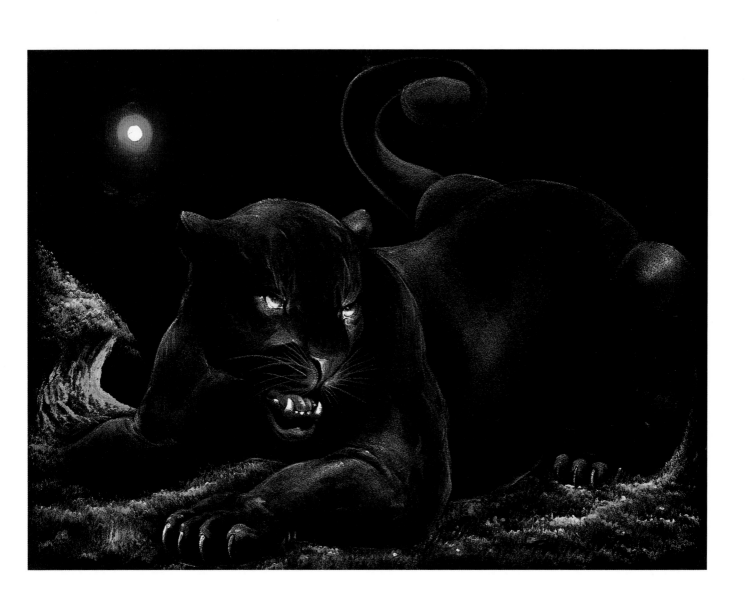

GERONIMO

Mass-produced, Juárez;
artist unknown

Painting on black velvet

27¼ x 39 in.

Courtesy Kent and
Norene Berry

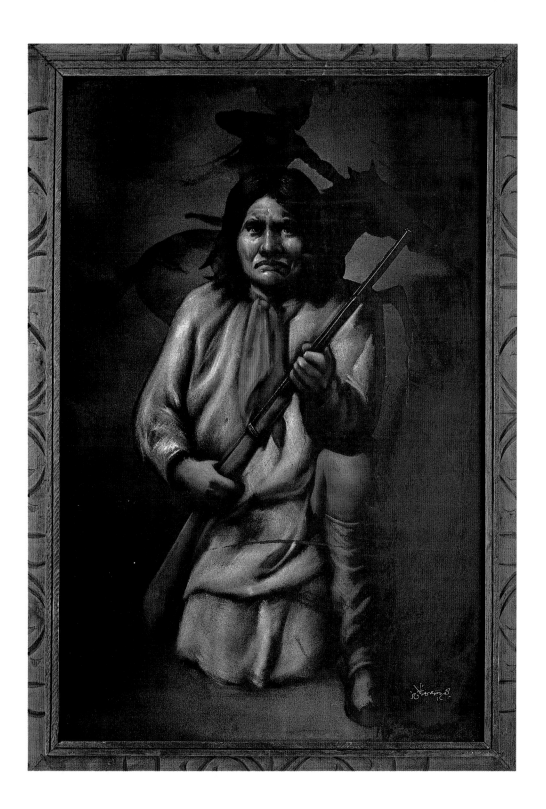

MADONNA

Mass-produced, Juárez;
artist unknown

Painting on black velvet

$18\frac{3}{4}$ x 23 in.

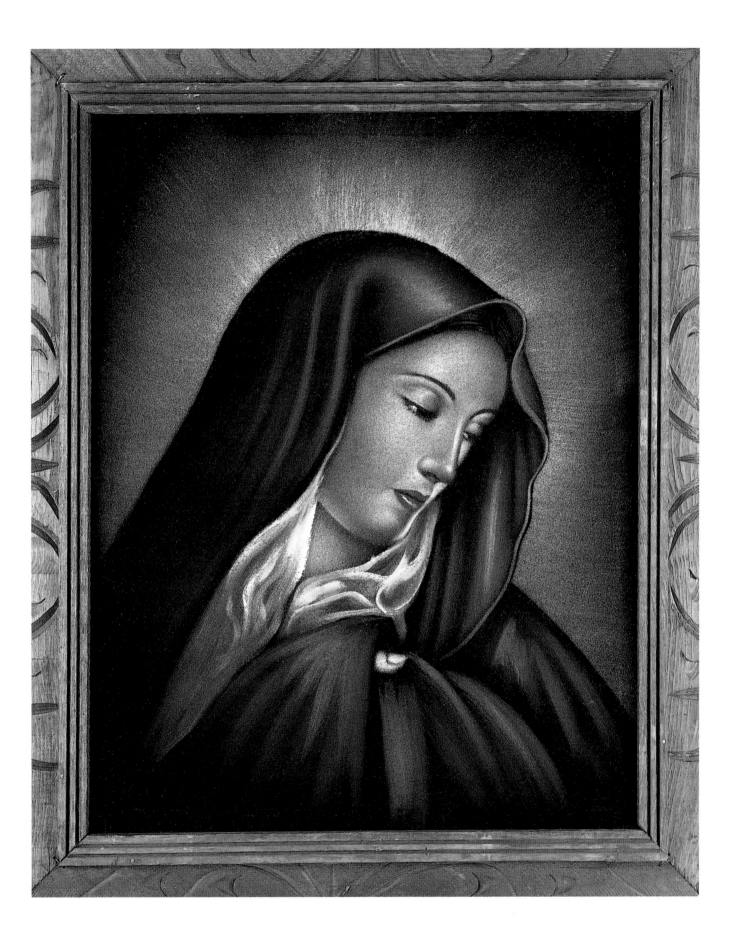

GUARDIAN ANGEL

Mass-produced, Juárez;
artist unknown

Painting on black velvet

18¼ x 22½ in.

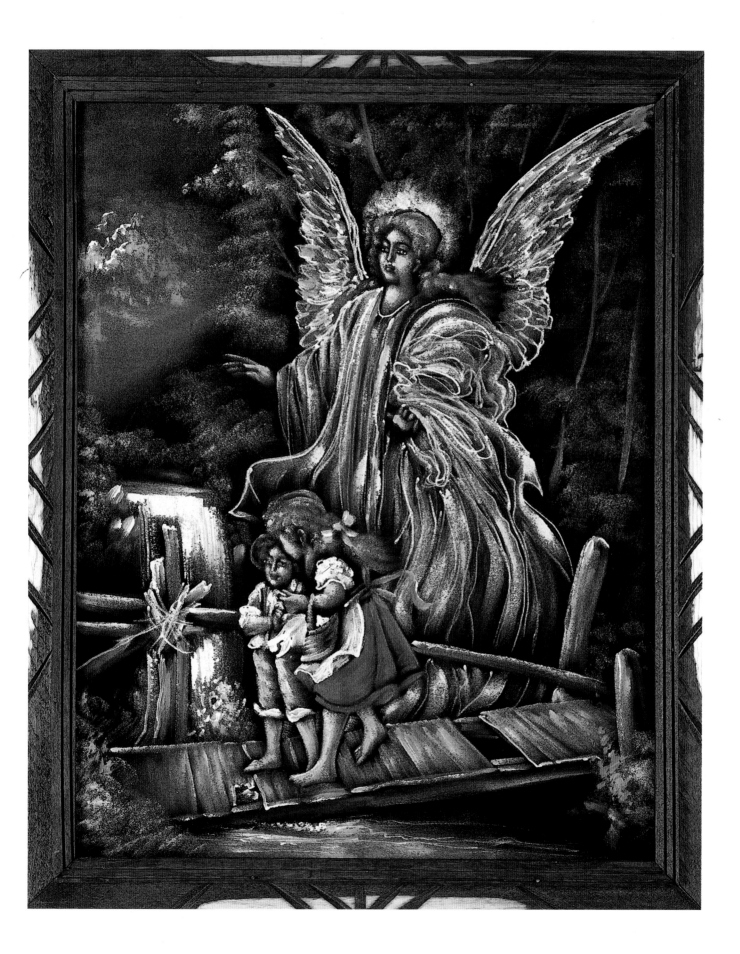

SAD CLOWN

Artist unknown;
purchased at flea market

Painting on black velvet

13½ x 16 in.

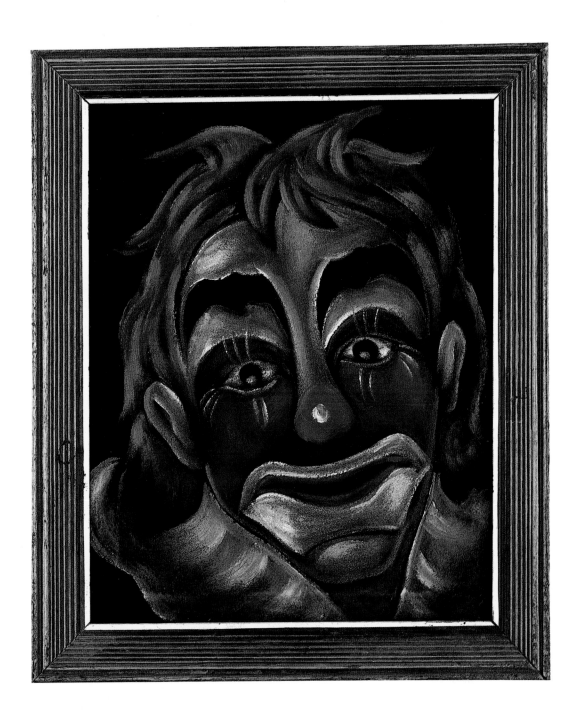

BLUE ELVIS

Mass-produced, Tijuana;
artist unknown

Blue and white airbrush
on black velvet

18 x 24 in.

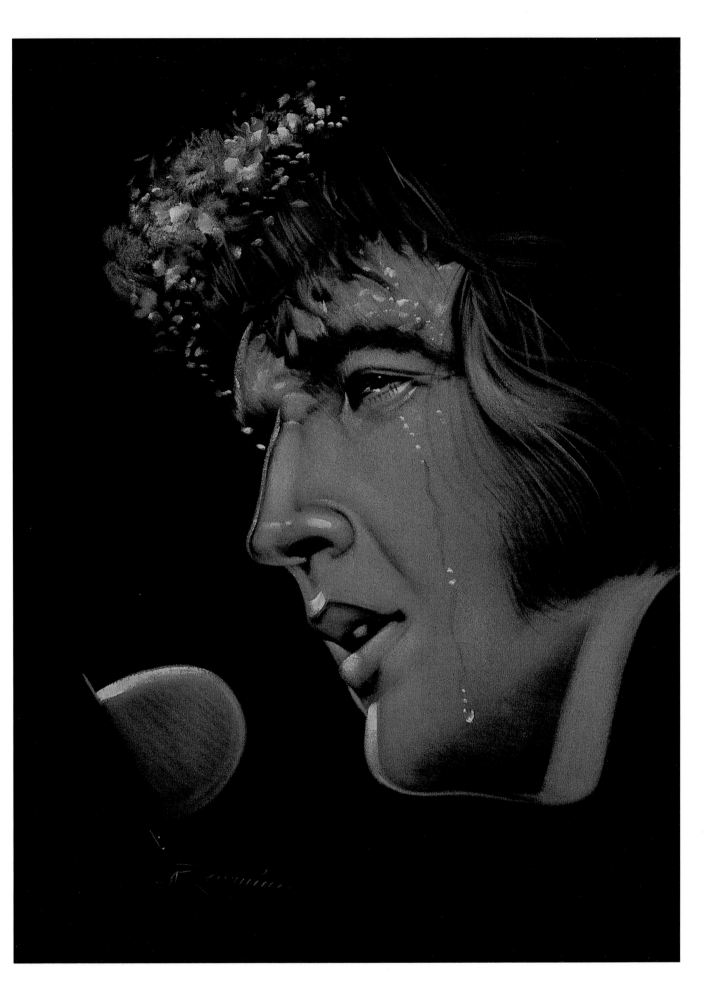

VALU-VILLAGE
CONQUISTADOR

Artist unknown;
purchased from thrift shop

Painting on black velvet

29½ x 42 in.

Courtesy Tree Bernstein and
Damian Lauria

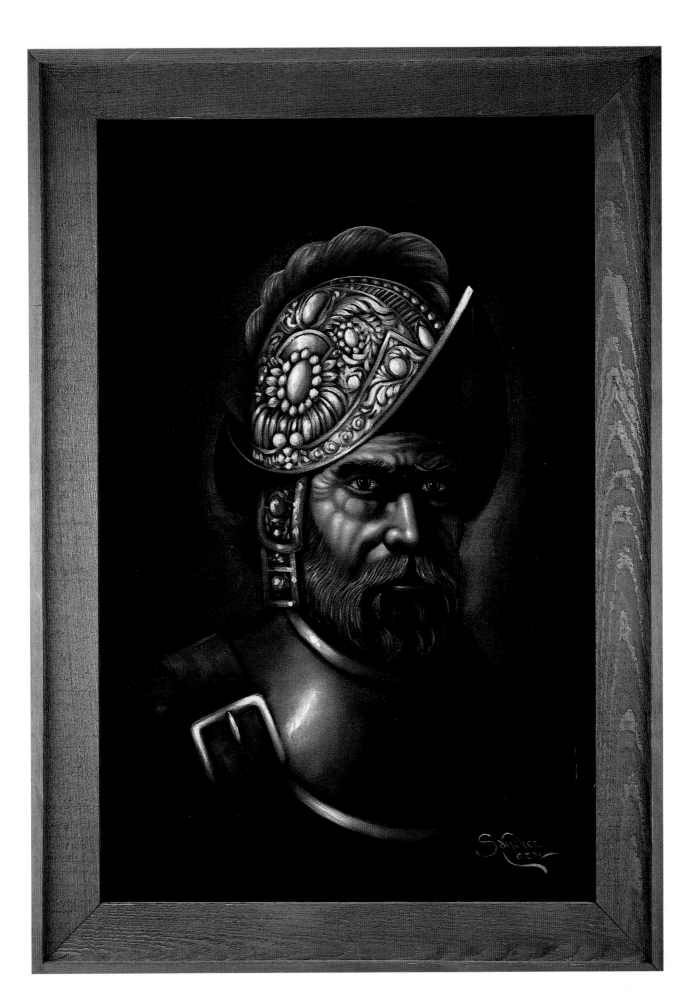

BLUE
(RUMBLINGS)

Benito Huerta
(Houston, Texas)

Oil, straw, encaustic,
wood, wire and enamel on
canvas and velvet

66 x 106 x 1½ in.

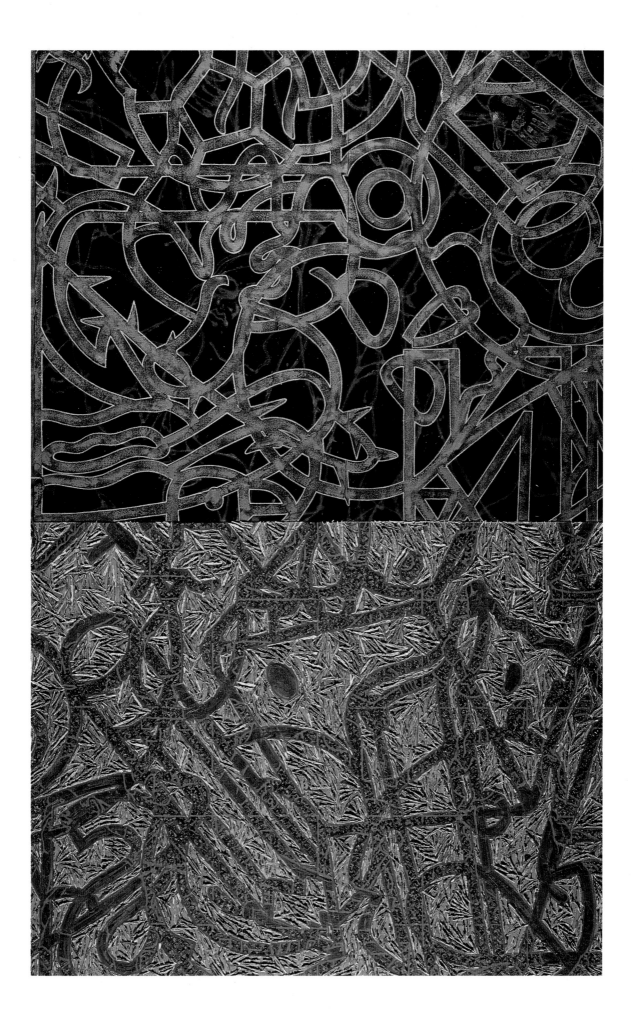

THE HIVE

Benito Huerta
(Houston, Texas)

Oil, lead, ribbon and thread
on wood and velvet

60 x 66 x 1½ in.

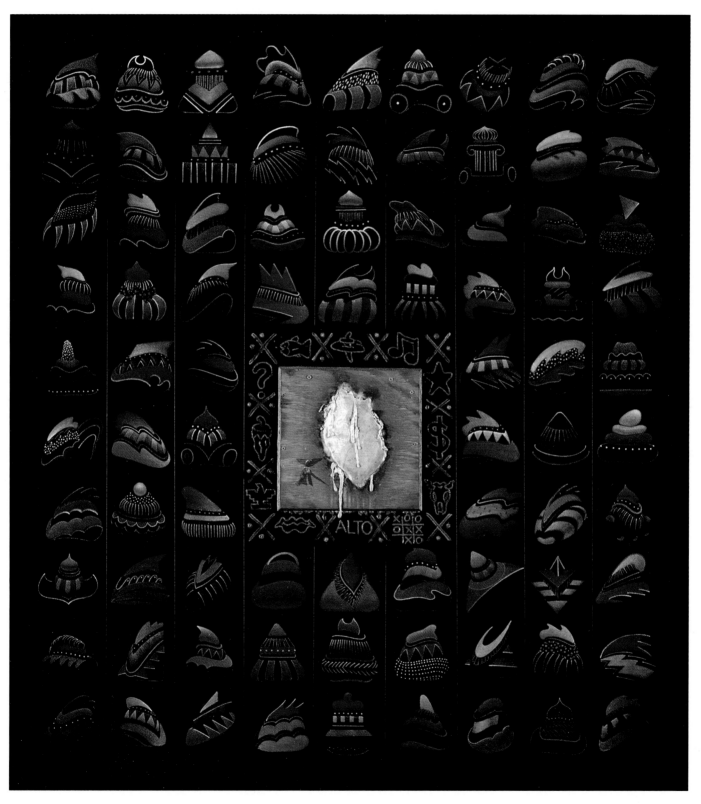

OLD HOMESTEAD

Antique American oil painting
on black velvet;
artist and date unknown

30 x 18 in.

Courtesy Linda Ellis

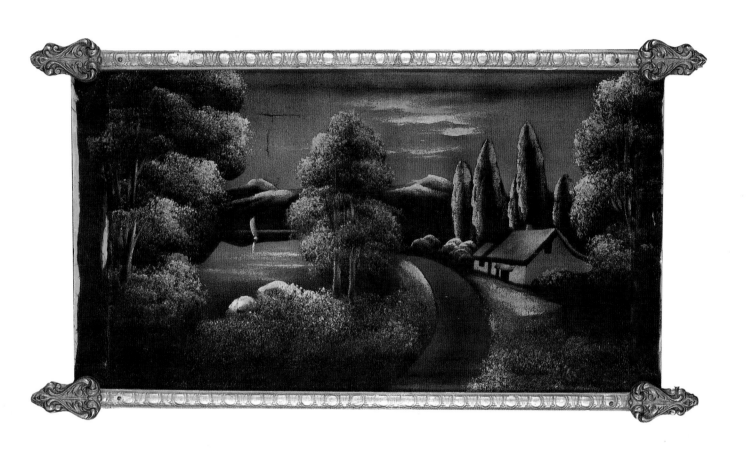

DEER IN
FULL MOON

Antique American oil painting
on black velvet;
artist and date unknown

$24\frac{1}{2}$ x $12\frac{1}{2}$ in.

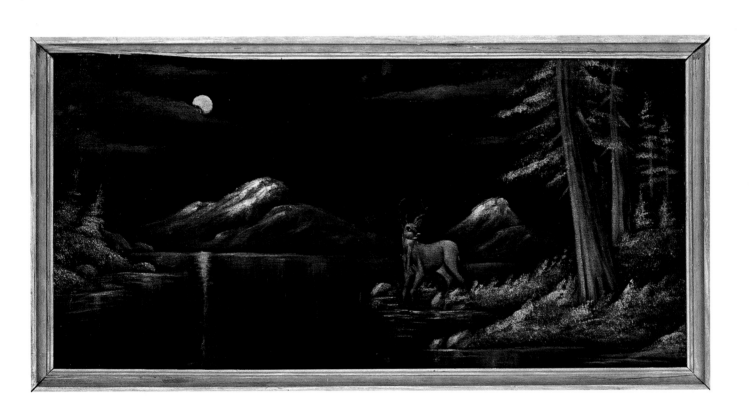

IXTACCÍHUATL AND POPOCATÉPETL

Tawa (Tijuana)

Painting on black velvet

39 x 27¼ in.

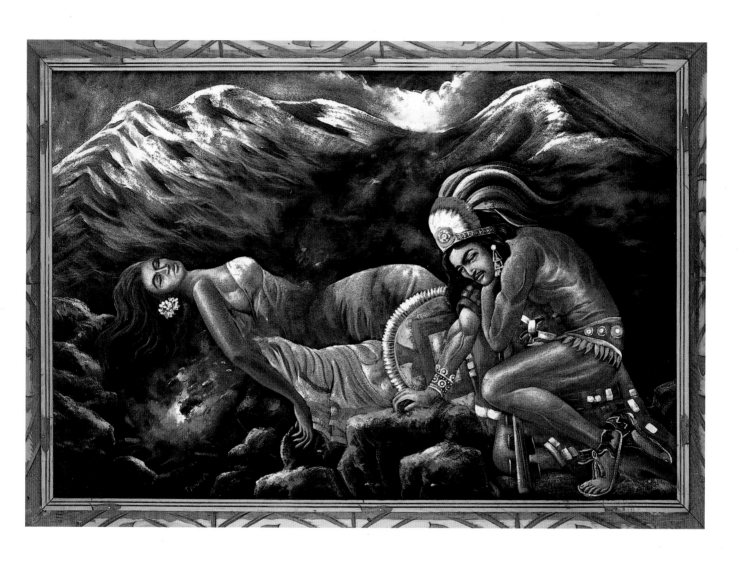